300
WRITING
PROMPTS

ISBN-13: 978-1-62009-692-1

What is your favorite way to spend a lazy day?

10/13

Have you ever spoken up when you saw something going on that was wrong? Were you scared? What ended up happening?

What is your favorite work of art? What do you love about it?

Write a diary entry, dated 10 years in the future.

Give your city (or town or region) a new name that reflects what type of place it is, and explain why you chose that name.

Write about something presently in your life that is "worth it."

You are the wind's interpreter. What is it saying?

Come up with a mathematical formula to express something you know/believe.
(Example: Long Saturday run + Frappucino = Happiness)

Name one thing you have lied to yourself about. Why did you do this?

What did you get into trouble for the most when you were a kid?

Do you prefer taking risks or having a safety net?

Complete this thought: "I wish I had paid more attention when..."

What do you look forward to every week?

Were you born to shine in one special way? What makes you really stand out?

What stupid question have you heard someone ask (or asked yourself)?

When was the last time you got lost?

What area of your life do you tend to enjoy in excess instead of moderation?

Write about three realistic goals you would like to achieve in your lifetime.

List a few phobias you have. When and how did you discover you had these fears?

You are a children's book writer. Write the first few lines of your new book.

If you had been able to choose, would you rather have been an only child or part of a very large family?

If I looked into your fridge right now, what would I find?

Have you ever experienced something that just could not be logically explained?

What do you need right now?

It is the end of your life and you are up on stage being presented with a major award. What award is it, and what have you won it for?

What modern technological device takes up most of your time?

Have you ever had the rotten experience of having to put a pet down?

Have you ever lived in another country besides your country of birth? Would you want to?

What is the first thing you do when you wake up every morning? Why?

Write about something you purchased used.

What color do you feel like today?

If you were to teach as a career, what would you teach?

Write about a time everything changed in the blink of an eye.

Write about a souvenir you have bought or received.

What is the biggest trigger for stress in your life?

What was the last thing you read, heard, or saw that inspired you?

Complete this thought: "I wish an alarm would notify me whenever..."

What are you recovering from right now?

Write about something you would still buy if it cost twice as much as it costs today.

What do you think is the most important thing for today's kids to learn in school?

What is the best road trip or vacation you have ever taken? Who was there? Where did you go? What did you see along the way?

You look outside: Ah, it is snowing! But look closer. Those are not snowflakes falling from the sky! What is it snowing at your house?

What have you been able to accomplish this year that you are really proud of?

Do you have a tattoo? What is it and why did you get it? If not, would you ever get one? What would the tattoo be, and what would it symbolize to you?

Write about something you frequently forget.

Describe one odd item that you have in your purse or wallet right now.

Write a quick love story. The story must end badly.

Why do you think some people are successful in life and others are not?

Look around you and choose an object in the room. Now write something from the point of view of that object.

Write about a memory you have related to a campfire.

What is a memory you would like to erase?

What traffic sign best reflects your life right now?

Think about the various roles you play in your life. If you had to give up all but one, which one would you keep?

What do you do, even when you do not feel like it?

What do you think is the most important question in life?

In what way are you strong?

Complete this thought: "Someone really needs to design a better..."

What is the last thing (or one of the last things) you searched for on the Internet? Why?

What do you love doing that you wish you could get paid for?

In what way are you selfish?

When have you experienced "heaven on earth?"

How do you act when you are afraid?

Write about a good discovery you have made (big or small).

Are there any lines that you simply will not cross?

Write about a messy area in your home, workplace, or life.

Write briefly about one thing in your life that is simple and one thing that is complex.

What takes too long?

Which household chores are you responsible for? Which do you hate doing? Which ones do you actually like?

If you were a book, in which section of the bookshop would you be shelved? Which genre are you most drawn to?

What is the best excuse for being late that you have ever heard or used?

If your house was on fire, what would you grab before escaping?

Describe your favorite article of clothing.

Write about an item you own that is not worth much money but has great value to you.

How do you strive to be similar to, or different from, your parents?

If you had unlimited time and money, what would you do to help your friends and family? What about strangers?

When was the last time you pulled an all-nighter? Why did you do it? How did you feel afterwards?

What is your favorite holiday ornament or decoration? What makes it so special to you?

Do you have anyone in your life that has acted as a mentor to you? Have you ever helped someone else out in this way?

What special traditions or holiday celebrations does your family observe?

Do you prefer to read electronic books or paper books? Why?

Complete this simile: "As awkward as _____."

Have you done any research into your ancestors? What interesting surprises have you discovered?

Think back to your childhood. Write about an article of clothing or an outfit you remember one of your parents (or another influential adult figure) wearing.

Describe (in a creative way) how you feel when you have a head cold.

Write about a time you said no.

Write about the most recent gift you gave someone.

Describe a time you cared for someone who was sick, or someone cared for you.

Write about the last time you felt guilty.

What expert do you wish could come teach you what they know?

It is been said, "You are what you eat." Rewrite that phrase: "You are what you
_____."

Write about a memorable experience you have had staying at a hotel.

Imagine you are a news anchor. Write the beginning of tonight's newscast. Make the top story what you truly think could happen today, or what you wish would happen today.

You have two hours to do something relaxing and a budget of $100. What will you do?

Think of a celebrity you would like to have dinner with. Write a note that just might catch that person's attention enough for him/her to agree to the dinner.

If you could have one talent that you do not naturally have, what would it be?

Where would you like to go on a day trip? You must drive there and back in one day, but you have unlimited funds for gas, food, and activities.

You have a child and you have written one piece of advice that will be carried in his/her pocket for life. What is that advice?

What is your favorite game to play?

Do you absolutely hate any food that other people usually like?

Do you have any dreams that recur? Why do you think you continue to have that dream?

Write about a song and the memories or feelings it evokes in you.

Periodically we have tension build up in our lives that requires a release of some kind. Some people cry; others punch; some find a creative outlet. What is your release?

If you had lived hundreds of years ago, what kind of work do you think you would have done? What job would you have wanted to do?

Write about something you made by hand.

What is the weirdest name you can come up with (or know someone with)? If you had to give a character a really, really unusual name, what would you choose and what would it show about their personality?

Where do you like to do your journaling? At a desk, in your bed, at the coffee shop?

If you woke up tomorrow and discovered that everything in life was now free, what is the first thing you would do?

If this week had a theme to it, what would yours be?

What is one of your greatest blessings?

Write about an interesting date you have been on, good or bad.

What do you have to do today that you really would rather not do?

Write about the middle of something, anything!

What is something you have learned lately?

Write about the beach: your favorite memory of a trip, what you love, what you hate (e.g., sand gets everywhere). Would you live on the coast if you could, or is it better just for a visit?

Snakes: interesting or creepy? Why?

What is something totally overrated in your world?

What is something you just need a kick in the pants to finish?

You have magic soap. What does it wash away?

Where would you be pleased to find yourself locked up overnight?

Which do you prefer: sunrise or sunset?

What do the clothes you are wearing now say about you?

Look around you right now. What is wrong with this picture?

Write about an experience you had when you lost track of time.

Write about an extracurricular activity you did when you were growing up, and how it affects (or does not affect) your life now. If you did not do any extracurricular activities, write about what you would have liked to do.

If and when you become the Supreme Ruler of the World, who will be your top advisor?

How do you react when someone compliments you?

Fill in the blanks: "I would like to march right up to _____ and say, '_____.'"

What is a sure-fire way to distract you from the task at hand?

What would you like to put in storage?

What do you and your spouse or best friend have in common?

What do you spend most of your time doing every day (when you are not writing)?

Have you ever made a friend with, or fallen in love with, someone you met online?

When was the last time you felt needed?

Have you ever been significantly more or less physically fit than you are today? What was different about that? What was easier? Harder? Did others treat you any differently?

Write about your first home: your childhood home or your first apartment or house of your own.

Write about one of your most embarrassing moments.

As a kid, what job did you dream you would have as an adult? What job do you have now?

Write a one-minute "Thank You" note to someone.

What is something you would like to see invented that would make your life easier?

Complete this thought: "Today I hope..."

Describe your memories of a piece of furniture from your childhood home.

A new Broadway musical is about your life. Come up with a title for the big show, and write a mini-review of it.

Describe a "first day" in your life (first day of marriage, of school, etc.).

What hat bad habit would you like to change?

What was the first thing you ever saved up your money to purchase?

What keeps you from getting a good night's sleep?

If you could spend a day living the adventures of any cartoon character, which one would you choose?

Write about a piece of jewelry you own. Where did it come from? When do you wear it?

If you could win a lifetime supply of anything you choose, what would you choose?

Do you have an ex that you would ever consider dating again? (If not, how bad were they?)

Write about a recent decision that you have made.

Does writing change you? How does writing make you a better person?

What is your mom like?

If you could go back in time exactly 10 years and give yourself some advice, what would you tell yourself?

Make up a new ending for this saying: "People who live in glass houses should not..."

Write about an item you use frequently that you think (or hope) will be obsolete in 20 years.

Write about the most recent skill you have acquired.

Think about a time you were recently in public. Describe what you were doing from the point of view of a stranger observing you.

Do you consider yourself an introvert or an extrovert? How does this compare to how others see you?

Write about a time you broke something.

What, in your opinion, is strength?

Imagine you are planning a trip across the continent on which you live. Assuming you have unlimited time, resources, and energy, what will be your mode of transportation?

How do you soothe yourself when you are upset?

Write about a time you had to let go of something you loved or wanted.

Were you ever involved in a school play as a student? Did you act, sing, design props, play an instrument, or hold prompt cards?

What is your favorite breakfast to get you up and out the door?

What has made you angry this week?

What is the most offensive thing you have ever heard anyone say?

What do you want your retirement to be like?

What one issue is most important to you when voting for political candidates?

If you could pack up and leave on vacation today, where would you be off to?

What is the weirdest thing you have ever eaten?

What modern technology would you have trouble living without?

If you had the opportunity to write as a career, what would you write?

What is your favorite room in your home or apartment?

Complete this thought: "I would never..."

Write about something nice a stranger did for you.

If you could be the best in the world at something, what would it be?

Is our world today a better or worse place than it was when you were a kid?

What book or book series did you wish would continue when you were done reading it?

Think of the last movie you saw. Write a review of it.

Describe in detail one item that you would love to inherit from a relative, or that you have inherited.

If you had a "do-over" button, what one event in your life would you like to have a second chance at?

When have you felt like "the new kid"?

Make up a really awkward description or ad for an online dating site.

What is the most useful tool you own?

What has ended recently in your life, or what new thing has just begun?

What is your favorite holiday, and what do you love about it?

Do you like your name? Do you feel like it suits you? If you could change your name, would you? What would you change it to?

In what one way should airlines improve airplane travel?

Write about the most important quality any mother should have.

What do you know is true?

It has been said that it is the little things that make life worth living. Describe one (or several) of those little things.

Break up your life (up to this point) into three chapters, and give each chapter a title.

Recall a memorable haircut or hairstyle you have had, given, or witnessed.

In what way do you not fit in with the family you grew up with?

Describe the most beautiful sound you have ever heard.

What is the best piece of advice you have ever been given?

Does your name have a meaning? If so, what is it? If not, make up your own meaning for it.

Who was your favorite band or singer when you were young?

Are you more like your mother or your father? Or are you more like someone else?

What is the best compliment you have ever received?

Describe your favorite comic strip or cartoon.

Would you rather spend the day at an art museum, science museum, or history museum?

What is a personality trait you admire in other people?

Write about the weirdest job you ever had.

Do you prefer to dance with no one watching, with a group of friends, or with one special partner?

Write about a moment when you felt proud of yourself.

What date do you have circled on your calendar? That is, what upcoming date or event are you looking forward to?

Describe your ultimate sandwich.

What is your favorite CD or album?

Describe a way a friend supported you when you needed it.

What is the worst emotion a human being can feel?

What is the best pickup line you know?

What are some of the hard facts about life?

Which is stronger, love or hate?

If you could live to see any event in the future, what would that event be?

Does religion play an important role in your life? Why or why not?

What do you believe happens after we die?

What do you look for when deciding whether or not to date someone?

Who has been the best leader of your country, past or present (e.g., president, royalty, prime minister, etc.)?

Have you ever been cheated on?

What are your thoughts about euthanasia?

If you had a child who had done something very wrong, such as stealing, how would you punish them?

Do you do good things when no one is watching?

Were you ever bullied as a child? Tell a story of a time you were bullied, or a time you observed someone being bullied.

Rewrite some of these commonly used idioms to make them more interesting, or maybe start a story: "Pardon my French," "My mind is in a fog," "There is more than one way to skin a cat," "You are on thin ice."

What requires your patience today?

What would you like said about you at your funeral?

Is there a mistake you keep making repeatedly in your life? Explain.

Should kids be allowed to have personal cell phones and tablets in school?

Are you making the world a better place?

What is a priority for you right now?

Describe the day you met your best friend, from your friend's point of view.

What is your favorite physical aspect of your partner? If you are single, describe something you like about a crush or your fantasy celebrity date.

Have you ever snooped in a friend or partner's house?

What do you want more out of life: happiness or success?

There is a strong current trend among kids to read comic books or graphic novels instead of regular books. What do you think about that?

Do you use coupons?

What do you think the biggest cultural differences are between your generation and your parents' generation?

How clean is your house right now?

Is there anything you are ever a snob about?

Do you have any piercings? Do you like them on other people? Does it matter where they are?

Do you recycle? If so, what do you recycle? If not, why not?

What is more important in a friend: someone who makes you laugh, or someone who is always there for you?

Do you have a favorite spot to go out for coffee or dinner? What makes this spot so great?

If you could change one personality trait about yourself, would you? Which one?

What is something you have learned in the past few days?

Name three things you have in your bathroom right now.

If you had a pet parrot, what would you teach it to say?

What is your favorite dessert?

Describe your first kiss.

If you could visit anyone on the planet right now, who would you go see?

What is the best thing about being either single or partnered (whichever you are right now)?

What do you think you are destined for in this life?

When was the last time someone truly listened to you?

If you had the resources and extra time to go back to school, what would you like to study?

What is standing in your way right now?

Why are families important? What do families provide that we cannot find on our own?

What is one phrase you would really like to hear right now?

Have you ever had something stolen from you?

Do you think table manners are important? Why?

If you could build your own vacation resort, what is one attraction you would definitely include?

You have been given $100 on the condition that you must spend it all on yourself. What will you do with your money?

What does spring look like in your neighborhood?

Imagine you are at your next high school reunion. How do you think your old school friends would react to the person you are today?

List 25 things you will never do.

Are you a sports fan? Do you watch or participate? Which sports?

Describe in detail a float you have seen in a parade.

Describe your most recent dream you can remember.

What was the last puzzle you worked on?

What kinds of items fill your bookshelves?

What kinds of recipes do you gravitate towards (e.g., desserts, casseroles, drinks)?

Have you ever been attacked by an animal?

What would life be like if unicorns and dragons existed?

What catches your eye about the architecture of a building?

What grinds your gears and really annoys you?

Do you like or have facial hair?

Describe your idea of a utopia.

Describe something you do not know that you wish you did.

Have you ever met someone who expressed emotion in an over-the-top way?

Why do you live in the city or state that you do?

Write about a teacher of yours who did something noteworthy.

Write about an event going on in your life right now, but see if you can write about it in the past tense.

Have you ever taken a huge risk? What was it, and was it worth it?

What is your favorite TV series?

Write about a time you said, "No!" as a child.

Do you remember your 21st birthday? Describe it as best you can.

Write about your first day at your current job.

Describe a wedding cake you have seen or had.

If you had to do it all over again, how would you reinvent your life?

Do you like horror stories? What is the best one you have heard?

Is there one of the arts that you just do not understand? Which one?

Describe one summer adventure from your childhood.

Write your own eulogy.

Imagine your life is now a best-selling book. Write the summary for the back cover.

Did you have a "lovey" as a child? Do you still have one?

What is something you deserve but do not currently have?

Describe your favorite photograph.

Have you ever cheated on a school homework assignment or a test? Do you still regret it today?